Raphael

Alexander Langkals

Prestel

Munich · Berlin · London · New York

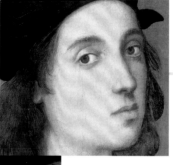

The Tools of the Trade

Learning the basics from his father _ Urbino and the court _
Perugia and Perugino _ The early Madonna pictures _ Maturing
to mastery _ Ambitious for greater things

To call Raphael the Madonna painter of the Italian Renaissance is certainly true as far as it goes. Throughout his creative career Raphael was preoccupied with the subject of the Virgin and Child and his artistic evolution can be followed in his Madonnas. It began with the study of his models and teachers, followed by the development of an artistic idiom of his own, which in turn became definitive for his successors. The question remains open as to whether his involvement with the divine subject affected his personality or not, but he was described by his contemporaries as extraordinarily amiable, with a sweetness of temperament that was capable of getting even the most difficult artists to rally behind him and unite in work. A near contemporary was the painter, architect and writer Giorgio Vasari (1511–74), who is now best known for his *Lives of the Most Excellent Painters, Sculptors and Architect*. In this work, written in the mid-sixteenth century, he describes the great artists of his day. Of Raphael he says: "With what liberality heaven can occasionally pour out the whole wealth of its treasures, all talents and outstanding skills, into a single person … is clearly evident in Raffaello Sanzio of Urbino, who stood out as much for his rare personal charm as for his unique genius."

Yet it would not do justice to Raphael if we did not look beyond his Madonnas. He executed portraits of important contemporary figures, and was summoned to Rome by the Pope to work on an extensive series of frescoes in the Vatican, an undertaking that lasted many years. He studied the art of Antiquity and absorbed its influence in his work; he was appointed master of the building work on St Peter's and set up a workshop with numerous pupils and assistants, at least one of whom (Giulio Romano, *c.* 1499–1546) himself became famous. Little time was granted him to achieve all this. He lived a mere thirty-six

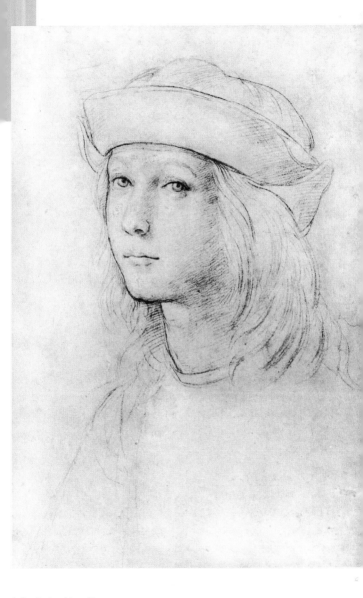

A first look at himself

Self-Portrait, *c.* 1498, chalk on paper, 38 x 26 cm, Ashmolean Museum, Oxford

years, dying on his thirty-seventh birthday after a short illness during
which the Pope visited him at his bedside almost every day.

Learning the basics from his father _ Raphael Santi (or Raffaello
Sanzio) was born in Urbino on 28 March or 6 April 1483. The uncer-
tainty derives from an ambiguous tomb inscription by Pietro Bembo
declaring that Raphael died on the same day of the year he was born,
i.e. Good Friday 1520, which was 6 April. However, in 1483 Good
Friday fell on 28 March. Raphael's father Giovanni Santi was a painter
who worked for the ruler of Urbino, Guidobaldo da Montefeltro and
his wife Elisabetta Gonzaga, and Giovanni himself taught his son the
rudiments of painting. Through his father, the boy also came into
contact with the court of Urbino. The youthful Raphael expressed
his loyalty to it by painting a *Portrait of Elisabetta Gonzaga* in 1502,
when he was just nineteen.

Urbino and the court _ The house where Raphael was born – a
remarkable example of fifteenth-century architecture – is in a street
now named after him, and offers an interesting insight into the sur-
roundings in which he grew up. Along with an early fresco by him, a
Madonna and Child, there is also a work by his father. Urbino was at
the time receptive to external artistic influences. Besides Italian mas-
ters, there were also Netherlandish and Spanish painters employed at
court. Even the colourism of Venetian painting, a particular way of

Hierarchic sublimity in mediaeval frontality

Portrait of Elisa-
betta Gonzaga,
1502, oil on canvas,
59 × 37 cm, Galleria
degli Uffizi,
Florence

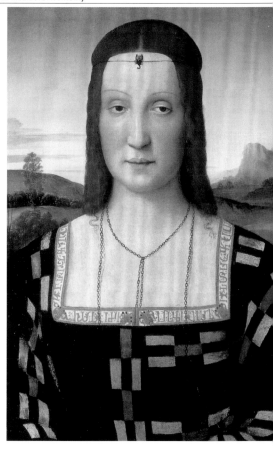

treating light and colour in pictures, spread this far. Urbino was one of
the most important humanist centres of Italy and had an outstanding
library – two important preconditions for an intensive engagement
with the philosophical, philological and literary innovations springing
from a revisiting of antiquity, which would become a key element in
Raphael's work.

Perugia and Perugino _ After learning the basics of art from his
father, Raphael was sent by the latter to Timoteo della Vita in 1495
for formal training. Here he had his first contacts with humanist and

Sacra conversazione (Pala Colonna), *c.* 1501/02, tempera and oil on panel, lunette: 65 × 171.5 cm, main panel: 169.5 × 169 cm, Metropolitan Museum of Art, New York

Coronation of the Virgin (Pala Oddi), 1503, oil on panel, mounted on canvas, 267 × 163 cm, Pinacoteca Vaticana, Rome

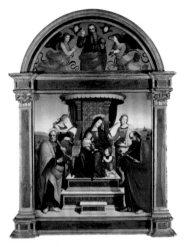 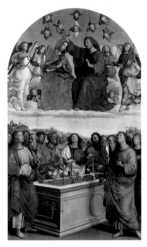

artistic circles. By autumn 1500 at the latest, Raphael was in Perugia, where he continued his apprenticeship in the studio of the famous Pietro Vannucci (Perugino). Presumably his father Giovanni had pressed for his son to be accepted there, as he considered Perugino a star – like Leonardo. But by the end of that year, Raphael was already an independent painter and had completed his first important altar painting (unfortunately extant only in fragments) for the nearby Umbrian city of Città di Castello.

The early Madonna pictures _ Raphael's earliest surviving altarpiece is a *sacra conversazione*, the *Pala Colonna*, which he produced for the nuns of Sant'Antonio in Perugia around 1501/02. The commission came his way presumably through the abbess, Ilaria Baglioni, the daughter of an influential family in the city. A striking feature of the painting is the monumentality of the figures, which suggests the influence of Fra Bartolommeo, who later became a friend. The Early Christian dress of the child and blue garment with gold borders round the head of the Virgin indicate familiarity with the frescoes of Pinturicchio in Spoleto, not far from Perugia. And the use of profile in the

St Catherine standing on the left goes back to Luca Signorelli, whose works he had seen in Città di Castello. Thus Raphael was already extending his range beyond his teacher Perugino by not only studying the greatest painters of his time but also making a synthesis of them in his own work.

Along with studying techniques for individual figures, from 1502 Raphael developed a system for organising larger groups of figures. The first opportunity he had to use it was in a commission from Pope Pius III (briefly in power in autumn 1503) to Raphael's friend Pinturicchio. For a fresco the latter did in Siena showing the *Departure of Aeneas Silvius Piccolomini to the Council of Basle*, it was Raphael who (according to Vasari) executed all the drawings and cartoons. By 1503 and the *Coronation of the Virgin (Pala Oddi)* and the predella with the *Adoration of the Magi*, Raphael was proving how deftly he could handle large figure groups in his own work. The lower half of the main panel is occupied by a largish group of figures that extends beyond the edge of the picture left and right. The picture acquired its present name from the client, Maddelena (or Alessandra) degli Oddi, who commissioned it for the family chapel in San Francesco in Perugia. The subtlety of execution shows Raphael already directly vying with Perugino. He had his teacher's stylistic resources now

... with his teacher

Adoration of the Magi, 1503, predella panel of *Pala Oddi*, oil on panel, mounted on canvas, 27 × 50 cm, Pinacoteca Vaticana, Rome

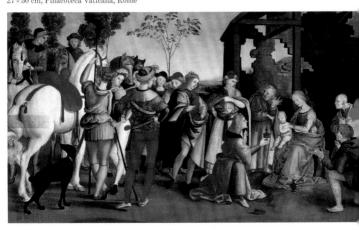

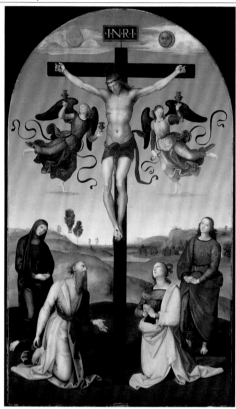

Crucifixion with Two Angels, the Virgin and Three Saints, 1503/04, oil on panel, 280 × 165 cm, National Gallery, London

completely at his fingertips. Raphael divided the picture into an upper heavenly part and a lower earthly part. Christ crowns his mother, and both are seated on a shallow belt of cloud surrounded by a semi-circle of music-making angels. Yet the figures in this 'firmament' really are firmly on solid ground, sitting or standing on the strip of cloud. The group is articulated by the sarcophagus of the Virgin cutting diagonally into the space. Lilies sprout forth as symbols of the Immaculate Conception. Saints Peter and Paul stand alongside St Thomas (Doubting Thomas), the disciple who refused to believe in the Resurrection unless he put his finger into the wound in Christ's side to convince himself. Thus the disciple who had the greatest struggle with his faith

Documenting youthful genius

Madonna with Child and St John (Diotallevi Madonna), 1503, oil on panel,
69 × 50 cm, Gemäldegalerie, Staatliche Museen Preussischer Kulturbesitz, Berlin

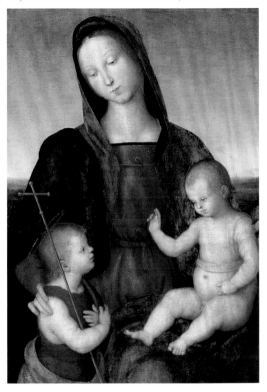

stands prominently in the centre of the picture, holding the Virgin's
girdle, which serves to convince him of another miracle here and now.

In the *Crucifixion with Two Angels, the Virgin Mary and Three
Saints* (1503/04), there are now only four saints, standing independent-
ly in the space beneath the Cross. Their heads form a spatial semi-
circle like the opening of a chalice. Christ and the two angels catching
his blood form the Host, which is held high. Raphael effects a clear
separation between the lower earthly and upper heavenly zones by
applying mediaeval status perspective with Christ and the angels,
the latter being smaller than the Son of God in accordance with their
importance. In the earthly realm, the laws of earthly physics apply.

The Dream of Scipio the Elder, 1504, oil on panel, 17 × 17 cm, National Gallery, London
The Three Graces, 1504, oil on panel, 17 × 17 cm, Musée Condé, Chantilly

 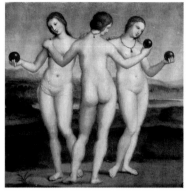

Maturing to mastery _ By 1503, Raphael had already established a reputation as Umbria's best painter. During this period, he worked on several paintings of a traditional iconographical type depicting the Child on the Virgin's lap – the Virgin with her familiar blue mantle round her head. One such example is the *Madonna with Child and St John (Diotallevi Madonna)* (see p. 11). The cross St John carries symbolises the future fate of the Child, who raises his arm in blessing.

Two small panels, both painted in 1504, are in several respects unusual for Raphael's late creative period from his time in Umbria. *The Dream of Scipio the Elder* and *The Three Graces* have identical dimensions. Presumably they formed a diptych or were the front and back of a painting. Apart from the portraits, they are the first pictures on secular subjects. The figures are developed further – they stand solidly on terra firma, and their movements are the result of their own actions.

Another small panel of *St Michael Conquering the Dragon* dates from the same year. Whereas in *The Dream of Scipio* the Netherlandish influence was generally evident in the landscape features, the elemental figures of Hell around St Michael are almost inconceivable without a prior knowledge of Hieronymous Bosch.

Ambitious for greater things _ At this date, Leonardo da Vinci and Michelangelo Buonarroti in Florence were both painting large-format

battle scenes and had developed a kind of rivalry. "When Raphael heard of it," reports Vasari in his *Lives*, "he was seized with such a violent wish to see this perfection that he dropped his work and, regardless of his own interests and convenience, hurried to Florence."

However, Raphael was not one to act in undue haste. He prudently armed himself with a letter of recommendation from Giovanna della Rovere, the sister of Duke Guidobaldo of Urbino, before setting off. The letter was addressed to Gonfaloniere Soderini, the head of the Florentine Republic. It was Giovanna's very great personal request that Raphael should be accorded the best possible reception and support in Florence.

Figures from Hell

St Michael Conquering the Dragon, 1504, oil on panel, 31 × 27 cm, Musée du Louvre, Paris

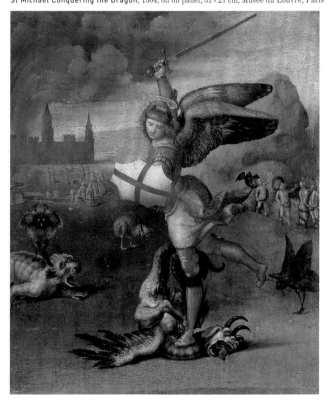

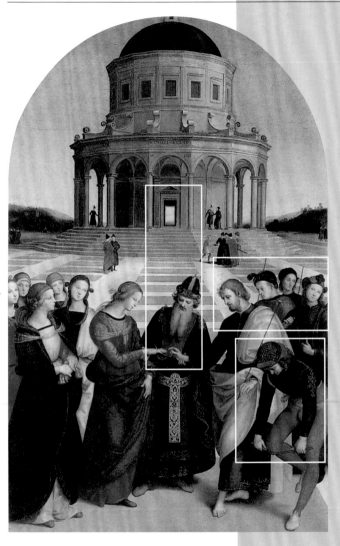

Wedding of the Virgin (Sposalizio), 1504, oil on panel, 170 × 118 cm, signed RAPHAEL VRBINAS, dated MDIIII over the arch, Pinacoteca di Brera, Milan

Wedding of the Virgin (Sposalizio)

The masterpiece of Raphael's Umbrian period _ New approach to architectural perspectives

Between 1500 and 1504, Raphael completed three altar paintings for the Città della Castello in Umbria. The scene of the *Wedding of the Virgin (Sposalizio)* dates from 1504, and is considered the masterpiece of his Umbrian early period. The picture remained in the Cappella d'Albizzini, in the church of San Francesco for which it was commissioned for, until 1789. Perugino had done a painting on the same subject for Perugia Cathedral between 1500 and 1502 and this served the young Raphael as a model. But even in those early days of his creative activity he was capable of surpassing the older painter and former teacher from his own native talent. He explored new terrain in the treatment of figures and human expressions, producing a freer, less static composition and handling the architecture of the temple in a new way. Vasari said of this: "In this picture he painted a perspective picture of a temple with such loving care that we can only be amazed at the difficulty of the task he set himself."

The whole width of the lower half of the picture is occupied by Mary and Joseph and their retinues. The priest in the middle brings the young people's hands together. Behind Joseph are the rejected suitors with their barren switches

– only Joseph's blossoms as a token that he has been selected. One disappointed suitor even breaks his stick over his knee. This figure is a direct borrowing from Perugino's picture, but in that it is set far in the background in the left half of the picture.

In fact, it seems Raphael was so taken with this figure that he brought it forward to a most prominent position in the foreground. Compared with Perugino's figure, the more natural and livelier pose Raphael gives us is conspicuous. This suitor is using force to break the stick, a dynamism totally lacking from Perugino. In Raphael, the figures move freely – the impulses for their behaviour come from within. This is more than purely a study of nature. They react to the most minor of feelings and are part of a whole context. The rabbi in Perugino is inwardly as well as outwardly unmoved. In Raphael, he becomes a priest helping the bride over her hesitation.

The ring is aligned exactly on the central axis of the picture, as Joseph holds it out towards his bride. Vertically above this, and not as in Perugino blocked by the rabbi's head, the eye falls on the door of the temple. This is supported compositionally by the perspective of the lines on the ground running together towards a vanishing point and the inclined attitudes of the heads around Mary and Joseph.

The two compositions are mirror images in a number of ways – Raphael switches the suitors from left to right, and changes the positions of Mary and Joseph. Even the light source moves from left to right. Raphael's skills are not limited to overcoming problems to do with figures. Even in this early work, he demonstrates his understanding of architecture, which would assume so central an importance in his Roman period. This is the first time that Raphael paints a building that could be built just as he shows it.

Beside all this, the composition contains an interesting system of proportions and arithmetical features. The dimensional ratio of the picture (2:3) is repeated in the position of the vanishing point. Five virgins and five bridegrooms flank the holy couple, making a total of 12 people in all – the number of signs of the zodiac and the apostles. The priest adds a thirteenth person – a parallel to Christ and his disciples. The temple has twelve columns and seven sides visible, an allusion to the gifts of the Holy Ghost and the seven Christian communities that St John turned to. The arithmetical features are important for the pictorial composition. If the painted temple were built, it would have sixteen sides, a number of no symbolic importance.

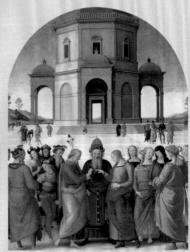

Perugino, **Nuptials of the Virgin**,
1500–02, oil on panel, 234 × 185 cm,
Musée des Beaux Arts, Caen

Honing his Skills

Florence: a new environment _ In moving to Florence, Raphael entered a bourgeois, democratic environment that brought together all the latest intellectual and artistic currents of the day. Art was collected here not just because of its religious value or as a public statement but also for its intrinsic artistic quality. Artists thought about traditional subject matter and came up with new ways of presenting it. The content, and technical and theoretical problems alike all interested them. In such stimulating surroundings, Raphael was soon held in great esteem.

Acceptance into society _ Raphael became acquainted with important artists, some of whom were to become friends. Giovanna della Rovere's letter of 1 October must have been extremely helpful here, since it expressed great personal concern that Raphael be accepted in Florentine society.

Vasari mentions Raphael's relationship with the humanist Taddeo Taddei, "… who, as an admirer of outstanding talent, constantly invited him to his house and to his table." Several breaks punctuated Raphael's period in Florence. Up to 1507, he spent time every year in Urbino. There he probably worked on commissions in the studio he had inherited from his father. They were for the Umbrian court, with which his links remained intact. Other small pictures for Florentine clients may also have been painted here.

Journeys to Perugia and Rome _ In 1505, Raphael visited Perugia twice and he must also have visited Rome that year. Several pages of drawings show him grappling with ancient Roman architecture. A drawing of the *Interior of the Pantheon in Rome* (see p. 20) was not intended to give a spatial impression. Raphael was more concerned with architectural features, the orders and proportions. Studying classical

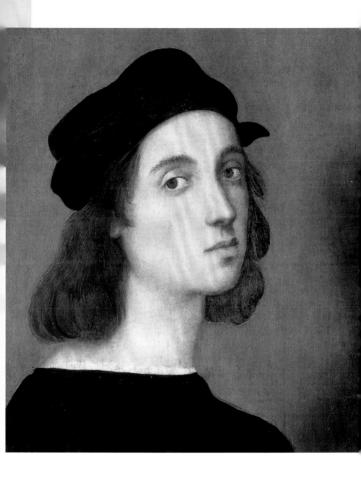

In the soft light of Leonardo

Self-Portrait, *c.* 1506, oil on panel, 45 × 35 cm, Galleria degli Uffizi, Florence

Interior of the Pantheon
in Rome, 1505, pen on paper,
40.7 × 27.7 cm, Galleria degli
Uffizi, Florence

architecture was not an end in itself – its influence would be evident in
subsequent paintings – and even in his Madonnas.

The visits to Perugia probably related to a commission for the
church of San Francesco there. In 1505, Raphael painted a great *Sacra
conversazione*, the *Pala Ansidei* commissioned by Bernardo Ansidei.
The Madonna with the Child in her lap is of the same type as earlier
pictures. As in the *Pala Colonna* of 1501/02 (see p. 8), the Virgin is
seated on a throne which screens her from the landscape in the back-
ground. In this case, the throne is noticeably narrower, leaving the two
saints more room. Overall, the figures look more earth-bound. The
importance of the landscape is much reduced, while the arch itself has
become a major architectural feature. The fine mouldings of the
imposts bear witness to his architectural studies. The graceful steps
leading up under the canopy raise the majestic throne to a height
appropriate to it.

Leonardo and Michelangelo as models

Raphael's encounter
with contemporary trends in art in Florence was not his first. Even in
his early years as an apprentice, he had learnt of them indirectly
through Perugino, whom he met again in Florence. There were also
direct links between Florence and Umbria. The Florentine sculptor
Verrocchio, whose work was so influential in late fifteenth-century
Florence, was Perugino's teacher, and Raphael's father Giovanni Santi
was greatly impressed by him. Raphael himself was friendly with the
Florentine monk Fra Bartolommeo (1472/75–1517), an important
pupil of Masaccio. Bartolommeo (born Baccio della Porta) entered the

A work for the family chapel

Sacra conversazione (Pala Ansidei), 1505,
oil on panel, 209 × 148 cm, dated MDV,
National Gallery, London

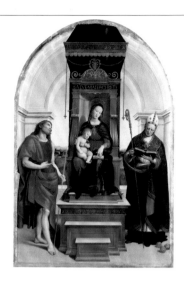

monastery of San Marco in 1499, and only resumed painting when he
met Raphael in Florence. Bartolommeo became his first mentor there,
instilling in him the Florentine feeling for form and space. But the
biggest influences were Michelangelo and Leonardo, who embodied
the other end of the stylistic spectrum. Raphael likewise drew particu-

Leonardo da Vinci (1452–1519) _ Leonardo was not
only a painter and sculptor but also an architect, writer, art theo-
rist, natural philosopher and technician. He worked in many Italian
cities, and finally in Rome as well, but his last years from 1516
were spent in France, working for François I. Inspired by the
Renaissance's typical humanist view of mankind, he explored every
field of knowledge. Most of his work resulted not from commis-
sions but from his own interests and lines of enquiry. The propor-
tion of his scientific illustrations and technical drawings is
markedly greater than his legacy as an artist. In his paintings, he
dissolved the corporeality of matter and created a new sensuality
by introducing atmospheric ambiguities.

Portrait of a Lady, 1505/06, pen on paper, 22.3 × 25.9 cm, Musée du Louvre, Paris
Portrait of Agnolo Doni, 1505, oil on panel, 63 × 45 cm, Gal. Palatina, Palazzo Pitti, Florence

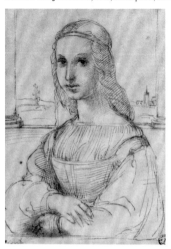 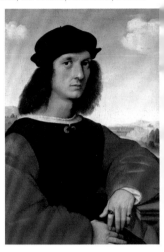

larly on them for inspiration in evolving a distinctive, integrated style of his own.

For example, around 1505/06 Raphael completed *Portrait of a Lady* in which the direct influence of Leonardo is clearly visible. Like

Michelangelo Buonarroti (1475–1564) _

Michelangelo saw himself principally as a sculptor, but his pre-eminence was no less as a painter, architect and poet. As an individual he was always an outsider and yet he remained throughout his life at the centre of artistic and cultural developments in Italy. Marked by discontinuities, his work incorporates both tradition and major new developments. In his early work, it was humanistic ideas that predominated, but from about 1530 a more subjective apprach took over. He is thus the outstanding figure of the High Renaissance and at the same time a prioneer of Mannerism. The strength of his large, heroic forms combined with clarity of drawing is what characterises Michelangelo's figures.

the latter's *Mona Lisa*, an oddly smiling girl sits with her arms crossed against a landscape background. The eyes and smile contain a hint of the enigmatic expression of Mona Lisa. The drawing was a study for Raphael's bridal picture *Lady with the Unicorn* – the unicorn symbolising the girl's purity.

Important patrons _ One of Raphael's patrons was the rich and highly respected merchant Agnolo Doni. The most celebrated and outstanding artists used to meet regularly at his house and Raphael was soon one of their number. Doni commissioned a Madonna from Michelangelo, but asked Raphael to paint him and his wife. *Portrait of Agnolo Doni* of 1505 shows a self-assured man leaning in a relaxed pose against a balustrade looking directly at the viewer with a searching gaze. Rings with large precious stones on his fingers indicate his wealth.

Clients become friends _ Often the relationship between Raphael and his patrons was not just of a business nature. We know that many a businessman fell under the spell of the artist's personality and concluded contracts with him as with a friend. The result was real

Painted for a friend

Madonna and Child with
St John (Madonna del Prato),
1506, oil on panel, 113 × 88 cm,
dated MDVI, Gemäldegalerie,
Kunsthistorisches Museum,
Vienna

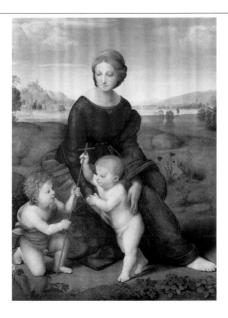

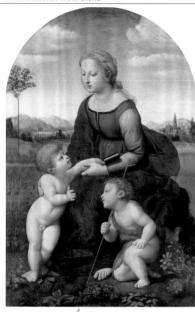

Madonna and Child with St John
(La belle Jardinière), 1507, oil on
panel, 122×80 cm, signed and dated
RAPHAEL VRB. MDVII, Musée
du Louvre, Paris

friendships, in the course of which Raphael gave many pictures away
as presents.

In 1506, Raphael painted *Madonna with Child and St John* or
Madonna del Prato (see p. 23) for Taddeo Taddei, who had taken up
Raphael almost as soon as he had arrived in Florence. Through him,
Raphael became acquainted with many important artists, while Taddei
himself became a friend. How much so is evident from a letter from
the artist to his uncle: "… If Taddeo Taddei comes to Urbino, he should
show him all honour without stinting and can you yourself please
also manifest all possible kindnesses towards him out of love for me
because I am, in truth, bound to him as much as to any man alive."

The evolution of new Madonnas _ According to Vasari, the
Madonna is not the only picture Raphael painted for Taddei. What we
have here is a new-type Madonna. The Virgin has come down off the
throne, the Child stands in front of her, she sits in the landscape and
has removed the robe from her head. She has in fact come much closer
to the earth and the viewer. No surrounding architecture separates

her from her environment. The feeling of freedom is tangible – a freedom that would be gradually developed during the Renaissance. Art at this time was generally throwing off the shackles of the horizontality and verticality of the Gothic style. The *Madonna del Prato* is bound up with a new composition system. Her body represents an isosceles triangle, and is often cited as the epitome of the 'triangular' composition typical of the Renaissance. With the head at the top, the kneeling St John and her outstretched foot form a safe area for the child to walk freely.

Geometric in structure but not in expression

Holy Family with St Elizabeth and St John (Canigiani Holy Family), 1507/08, oil on panel, 131 × 107 cm, signed RAPHAEL URBINAS, Alte Pinakothek, Munich

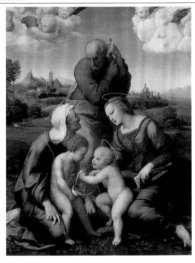

The *Madonna del Prato* was not the only representation of this subject composed as a triangle. Other paintings with different numbers of figures but still inscribed in triangles include the *Madonna with Child and St John (La belle Jardinière)* of 1507 and the *Holy Family with St Elizabeth and St John (Canigiani Holy Family)* painted c. 1507/08. In *La belle Jardinière*, Christ, the Virgin and St John form a tall, narrow triangle. St John kneels opposite the carefree, childish Jesus, the cross indicating that he knows what is to come.

The composition of the *Canigiani Holy Family* is even more interesting in its subtle sophistication. The five figures form a pyramid

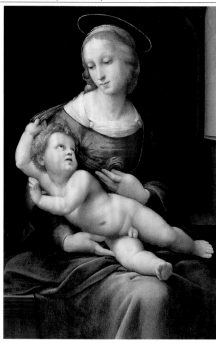

Madonna and Child (Bridgewater Madonna), *c.* 1507, oil on panel, mounted on canvas, 81 × 56 cm, National Gallery of Scotland (loan of Duke of Sutherland Collection), Edinburgh

made up in turn of two triangles and a diamond. The two mothers with their children are inscribed in a triangle, the figure of St Joseph looming above them. Raphael borrowed this arrangement from the œuvre of his friend Fra Bartolommeo. Also remarkable is the figure of St Elizabeth which is Raphael's first naturalistic-looking painting of an older woman. She too is derived from Fra Bartolommeo. Everything about this picture has an effortless, natural air. This is largely because Raphael did countless preparatory studies and preliminary drawings to find the right solutions for everything. And once he had got it all right, he found he had compositional solutions he could make use of in many other pictures.

Along with new compositional arrangements, Raphael painted other Madonnas focusing purely on the Virgin and Child. In this case, the two figures occupy almost the whole picture area. Often, the background landscape is more of a token than a scene. The *Bridgewater*

Holding hands

Study for the Bridgewater Madonna,
1506, silver point, pen
on brownish ground on paper,
25.6 × 18.6 cm, Graphische Sammlung
Albertina, Vienna

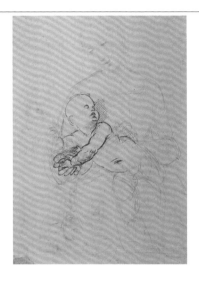

Madonna painted *c.* 1507 sits in a dark room. Everything focuses on
the young mother and her child. She gazes at her son with loving eyes,
who responds with a violent movement – a very intimate scene that
Raphael observed closely. This type of Madonna threw off the mediae-
val tradition entirely in accordance with the more human religious
emotions of the day. Only the Virgin's halo reminds us of the sacred
subject matter. The boy himself seems also wholly earthly – it is
scarcely the Jesus of Christianity. In an earlier *Study for the
Bridgewater Madonna* of 1506, Raphael concentrated particularly on
the figure of the child. The important parts are highlighted with force-
ful strokes of the pen. Attitude and gaze are as in the painting, but the
arms are treated differently. Mother and child hold hands. In contrast,
the boy in the painting adopts an attitude Raphael would repeat in
Rome years later. There it is not the Son of God with the Virgin. In a
similar arrangement, the boy features as a putto, leading Galatea's
dolphin (see p. 50).

Rome beckons _ At the end of Raphael's time in Florence, the death
of Duke Guidobaldo on 11 April 1508 sundered a link that was of great
personal importance. Raphael's eyes now turned towards Rome and
the pope, whose patronage awaited him.

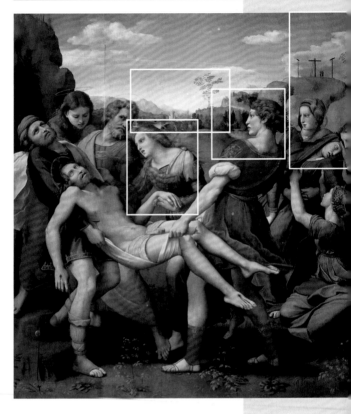

The Deposition (Pala Baglioni), 1507, oil on panel,
184 × 176 cm, signed and dated RAPHAEL./VRBINAS./
M.D VII, Galleria Borghese, Rome

Deposition

**A moment in time devoid of hope or vision — The Deposition as a
reflection of a family tragedy**

For painters of the Renaissance, the Deposition of Christ was a very
challenging subject, as it involved grouping and organising a great
number of people in the picture into an overall composition. In Florence,
spurred on by Leonardo and Michelangelo, Raphael had been pre-
occupied with the subject of battles. Numerous sketches and studies
survive, but as no commissions came his way, at the end of his Floren-
tine period he made use of the studies for a Deposition. The picture
depicts a moment in time devoid of hope or vision. Probably the situa-
tion was much the same for the client of the painting, Atalanta Baglioni,
who commissioned the *Deposition* (now called the *Pala Baglioni*) in
1507 for the church of S Francesco al Prato in Perugia. The painting was
intended as the social rehabilitation of her son after the 'Perugian
Blood Wedding'. The son had paid for a murder of a relative with his
own life.

The body of Christ is carried to the tomb by the whole group that had
stood mourning beneath the Cross shortly before. Below left, the steps
leading into the tomb are visible. The mist-shrouded mountains in the
distance at horizon level denote a depth of landscape. This technique of

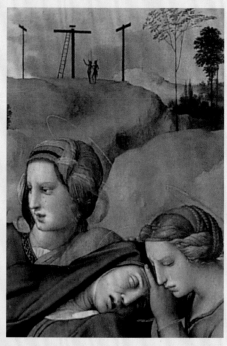

delicately blended tones is called *sfumato* and was first discovered and used by Leonardo in almost scientific fashion. The landscape with its details of valleys, river courses, hilltop cities and fortresses is reminiscent of Raphael's Umbrian homeland. In the middle ground, on the right, is the hill of Golgotha with the three crucifixes. That of Christ faces us, with the inscription panel at the top, while turned towards it at an angle on each side are those of the two thieves. The ladder used to remove the body from the Cross is still leaning up against it. The two diminutive figures appear to be the two soldiers, one with a spear used to pierce the dying Christ's side, the other with a raised arm telling what happened. According to the Bible, the skies grew dark at the hour of Christ's death. The overall scene is generally bright, but the scattered clouds are densest over Golgotha, the place of the skull. Directly beneath the Cross in the picture but

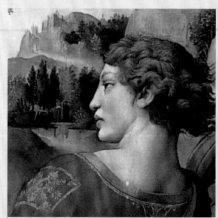

geographically much closer, the three other Maries prop up the swooning Mother of Jesus. Compositionally, the scene of the Virgin's distress is left directly beneath the Cross, and this is where we often find it in art history. The Virgin is shown collapsing as her Son's body is carried off to the tomb. His body is directed leftwards, while her head falls to the right. It is a parting of ways, at least for the time being.

The unusual figure of the strapping youth, the only person in the scene not obviously in distress, has been assumed to be an idealised portrait of Atalanta Baglioni's son Griffone. Standing in front of him is Mary Magdalene, visibly mourning Christ, her left hand holding up Christ's left hand. She is painted with very great delicacy, as is the thin material between the two hands. This motif of direct physical proximity forms the core of the picture. Everything else is built around it. The sensitive rendering of Mary Magdalene may be an allusion to Atalanta Baglioni's own pain at the loss of her own son. The incident in the Baglioni family took place only a few years previously, so the principal figures Raphael places centre stage may contain some reference to it. The angelic youth cannot be interpreted simply as a Christian symbol. He looks almost like a rebirth of a classical ideal. Certainly, not much later Raphael was definitely trying to blend Christian and classical ideas. This figures heralds his ambitions in this respect.

The Vatican Calls

Summoned to Rome by the Pope _ Thanks to the good offices of Donato Bramante, Raphael was invited to Rome by Pope Julius II. Like Raphael, Bramante came from Urbino and was the architect in charge of rebuilding St Peter's in Rome. Raphael's relocation appears to have been hasty, as a number of his paintings remained behind in Florence unfinished.

By autumn 1508, Raphael was in Rome, at the time a city with only around 40,000 inhabitants. Its sole claim to importance was as the seat of the popes. It was here that Raphael received his greatest commissions from a pope whose aim was to establish a powerful church state. Noted for his forceful personality and iron will, Julius himself was known to take to the back of his horse in times of war.

Major painting programme for the papal rooms _ As far as the Vatican was concerned, Julius wanted great changes. Its appearance then had nothing of its present grandiose dimensions and showiness with the huge open piazza in front. The palace looked like a torso and Julius II had no intention of living in the rooms his ghastly predecessor Alexander VI Borgia had occupied, preferring instead another series of rooms that have since become world-famous as the Raphael Rooms or Stanze. These consist of a suite of three rooms and a hall. Several artists had been at work on the rooms, but Julius dismissed them all in favour of Raphael. The Stanze were named after their frescoes: *Eliodoro*, after the scene showing the expulsion of would-be robber Heliodorus from the temple in Jerusalem (*c.* 176 BC); the *Stanza dell'Incendio* (Fire Room) after the great fire in the Borgo, the district outside the Vatican, and the *Sala di Costantino* after the scene of Constantine's victory over Maxentius at the Milvian Bridge (312 AD). Only the *Stanza della Segnatura* got its name from the function

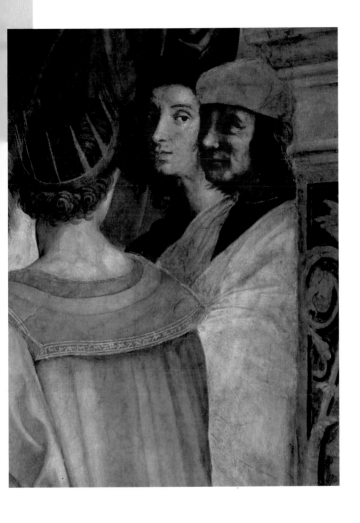

Companion of the leading thinkers of antiquity

Self-Portrait, detail from **The School of Athens**, 1510, fresco, Stanza della Segnatura, Vatican, Rome

The Judgment of Solomon, 1509/10, ceiling fresco, 120 × 105 cm, Stanza della Segnatura, Vatican, Rome

of the room at a later date – the signing of papal bulls and other documents and application of seals. The painting of the *Stanze* was not completed in Raphael's lifetime – four years after his death his studio was still at work in the last room.

Julius used the Stanza della Segnatura as a library and reading room. Raphael's notion of how a room of this sort should be painted (with a host of philosophers, theologians, literati and other scholars) came from Urbino. In Urbino, Duke Federigo had had a small study

Humanism _ Searching for a new ideal of education, the second half of the fourteenth century in Italy and subsequent generations found an answer in a return to Antiquity and the Ancient authors such as Plato, Cicero and St Augustine, combined with a critical study of their writings. Of the seven liberal arts, the humanists valued rhetoric particularly. Their intellectual attitude stressed the value of the individual, and abandoned mediaeval notions of the universal unity of spiritual and secular rule. Humanism flourished in Florence and Rome, the courts of princes and even the early papacy, seeking a link with Christianity, and was taught in academies set up on classical models.

decorated with symbolic female figures of the seven liberal arts. The other disciplines found their place among them. This was the concept that Raphael now took with him to the Stanza. He put the female figures on the ceiling, while the philosophers, poets, theologians and other scholars filled the walls, though he restricted them to the disciplines of theology, philosophy, law and poetry. For each, he developed extensive figure groups that occupy the walls to their fullest extent. Above the wall frescoes four allegorical figures are painted in round

The centre of faith ...

Disputa, 1509, fresco, base length *c.* 770 cm, Stanza della Segnatura, Vatican, Rome

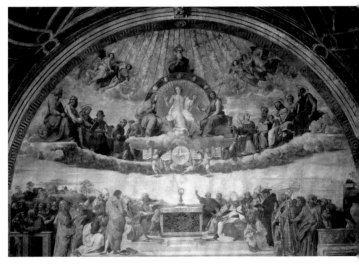

painted areas. In the corners are four other pictures relating to the wall frescoes. The corner over the frescoes of Justitia and Philosophy shows *The Judgment of Solomon* from 1509/10, representing the link between wisdom and justice.

The two wall surfaces opposite are 23 feet (7m) high and 33 feet (10m) wide. On them, facing the philosophical world, Raphael presents the theological or religious world. Whereas the philosophers of the *School of Athens* gather in a splendid interior, the theologians of the *Disputa*, painted in 1509, are shown in a landscape. In the *School of Athens* it is philosophers Aristoteles and Plato who form the focal

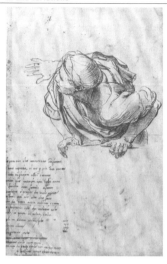

Studies for the Disputa, 1509, pen on slate pencil preparatory drawing, 36 × 23.5 cm, Musée Fabre, Montpellier

point. Here in the *Disputa* all the people in the lower earthly zone are grouped around the central altar, or more precisely the host in the monstrance. Above it, accompanied by putti, hovers the dove as the symbol of the Holy Spirit, and successively above that, on a strip of cloud, the Risen Christ with the Virgin and John the Baptist, then God the Father. The central perspective steers the viewer's eye unobtrusively to the vanishing point, focused in the host. This is supported by the positioning of the figures on the ground, standing on rising steps, and the semi-circle arrangement of deceased saints above.

Raphael works up his figures to the smallest detail. Even apparently marginal figures like the one leaning on a balustrade on the right get the full treatment of preparatory sketches. In these, the artist tries out various poses – in one version, this observer of the scene supports himself on two hands, while in another he props himself against an imaginary wall with his right hand on the head side. As in other paintings, Raphael's close links with his own world are manifest in his depictions of well-known people. In the left background an old Dominican monk stands gazing at the heavenly vision. This is the painter Fra Angelico and, therewith, a tribute to the great master of the Early Renaissance.

A growing reputation and new appointment _ In his initial enthusiasm for Raphael's frescoes, Julius II not only sent away the other artists – including Perugino – but even had pictures they had just painted taken off the walls. On 14 October 1509, he appointed Raphael as the 'Scribe of Apostolic Bulls', an office with little work but regular pay and a high status.

The pope uses Raphael for his own glorification _ However, the freedom Raphael enjoyed when working on the first frescoes was increasingly spoilt by the pope. Julius had himself immortalised in a history painting after a military campaign in the person of a predecessor, Pope Gregory IX. Not least because of these interferences, Raphael accepted other commissions. As he was in growing demand, he was in a position to turn down work. The resulting portraits were executed with more natural precision than those he painted in Florence. The *Portrait of a Cardinal* was painted *c.* 1510/11, and is among Raphael's finest portraits. Moreover, its beauty is not external but mirrors the soul and character of the dignitary.

Handsome but unknown

Portrait of a Cardinal,
c. 1510/11, oil on panel,
79 × 61 cm, Museo del
Prado, Madrid

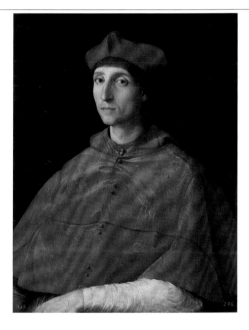

The Expulsion of Heliodorus, 1511, fresco, base length *c.* 750 cm, Stanza d'Eliodoro, Vatican, Rome

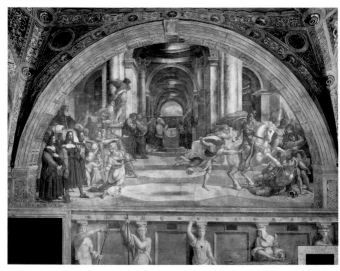

A large workshop established _ To cope with the huge task at the Stanze, Raphael employed assistants. The studio became a major affair, with at least twenty pupils known by name and as many again whose name we do not know. Some specialised in particular work. For example, Raphael had Marcantonio engrave paintings based on paintings he had done as drawings. For years, he came up with the ideas that apprentices and pupils carried out in drawings, engravings and paintings, or were even done by workers in architecture. He set draughtsmen to work in the whole of Italy and Greece drawing classical sculptures and buildings. Yet despite his new celebrity status, Raphael retained his amiable personality.

In the fresco of *The Expulsion of Heliodorus* dated 1511 in the second *Stanza*, Heliodorus, the favourite of the king of Syria, has fallen to the ground, alongside him the temple treasures he was about to steal. As he escapes, he is attacked by a horse ridden by a heavenly rider with two companions and is struck down. Here too the pope demanded to be included in the scene. The brilliance is no longer equal to that of the first *Stanza* (see pp. 35, 36) as the proportion of paintings done by

The light shows the way

The Liberation of Peter, 1512, fresco, base length *c.* 660 cm, Stanza d'Eliodoro, Vatican, Rome

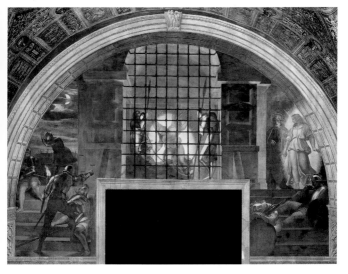

assistants grows. Parts of the paintings are by Giulio Romano, one of Raphael's best-known pupils.

The Liberation of Peter of 1512 is a nocturnal scene and is thought to be the first such scene of the High Renaissance. Neither the sleeping captive Peter nor his heavy-eyed guards notice the divine presence in all his risen glory, who leads Peter out of prison on the right. Several successive scenes are combined in this picture. An unusual feature is the coloration on the left, presenting unusual lighting. The pale moonlight, a flaming torch in the middle and the refulgence of the angel illuminate the scene – a remarkable example of the influence of Venetian colourism.

Madonnas remain a challenge _ Alongside the work in the Stanze, Raphael was still producing paintings of his 'old' subject – Madonnas. *The Madonna di Foligno* (see p. 40) is still clearly divided into heavenly and earthly zones. A choir of putti surrounds the orb of the sun, in front of which the Virgin and her Child look down from the clouds on the earthly realm. In the *Sistine Madonna* (see p. 41) of 1512/13, there is only a heavenly zone, the earthly realm being reduced to a raised

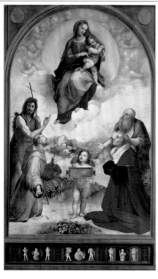

Sacra conversazione (Madonna di Foligno),
1512, oil on panel, mounted on canvas,
308 × 198 cm, Pinacoteca Vaticana, Rome

curtain and a narrow balustrade. The adoring host melt into the clouds
above which the Virgin hovers. With the Son of God, she looks towards
the worshipper, her divine aura illuminating the putti in the back-
ground. The adoring Pope Sixtus II has left his tiara as a sign of power
on earth on the balustrade. The picture was painted for a monastery in

An ordinary girl

Madonna with Child and St John
(Madonna della Sedia), 1513,
oil on panel, diam. 71 cm,
Gal. Palatina, Palazzo Pitti, Florence

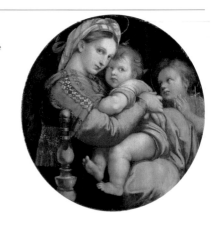

A glimpse behind the curtain

Sacra conversazione
(Sistine Madonna),
1512/13, oil on canvas,
265 × 196 cm,
Gemäldegalerie,
Dresden

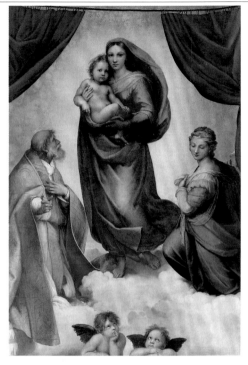

Piacenza. It was presumably Julius II's close connections with this
monastery that procured the commission for Raphael. When Augustus
III of Saxony acquired the picture in 1754, he is supposed to have got
up from his throne when it arrived, to make room for it.

A particular challenge of the Renaissance was in mastering the
circular format of the tondo. The ease with which Raphael handled
the format is evident in the natural-looking arrangement of the figures
in the *Madonna della Sedia* of 1513. It looks so self-evident that one
would scarcely imagine there was a compositional problem. In this and
similar pictures, Raphael continued his intimate series of Madonnas
from his Florentine days.

On 21 February 1513 Pope Julius II died, depriving Raphael of
an important patron. On 11 March Giovanni de' Medici was elected
his successor as Pope Leo X. A new era was beginning.

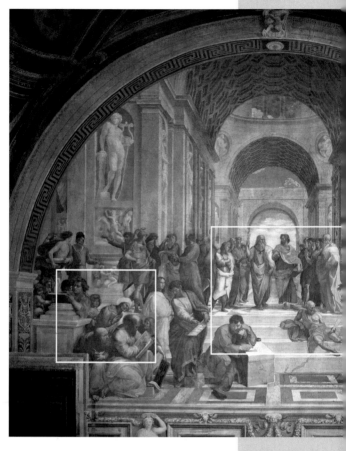

The School of Athens, 1510, fresco, base length
c. 770 cm, Stanza della Segnatura, Vatican, Rome

The School of Athens

Raphael's overall masterpiece – The revival of the intellectual spirit of Antiquity

Raphael's *School of Athens* in the Stanza della Segnatura is very often seen as the greatest work of his Roman period – indeed, his greatest work of any period. Dated 1510, it shows a gathering of the outstanding thinkers of Antiquity who had acquired particular importance for the intellectual world of the Renaissance. The combination of clarity of composition, accurate rendering of structure and perspective in the ideal architecture (which incorporates ideas of Bramante) and the presentation of a wide variety of figures in all kinds of poses have made this fresco the epitome of the Italian High Renaissance. Raphael blends influences of Leonardo and Michelangelo and even antiquity into a visual idiom entirely his own.

In contrast to the God-created natural setting of the *Disputa*, the philosophers are placed in an environment of man-made grandeur. Whereas the axis of the human figures is horizontal, the lofty vertical accents of the arches lend height and solemnity. Behind the philosophers are classical statues of Apollo, the god of harmony, and Minerva, the goddess of reason, in niches with mythological scenes beneath them. The environment established by Raphael symbolises the inner intellectual world of the philosophers who appear in it, with quite a number of the figures effectively being portraits. Captured as a moment in time, the ranks of philosophers from left to right

incorporate virtually a history of philosophy ranging from the birth of thought in mythology via the liberation of reason to the triumph of philosophy, the scepticism of truth and the application of discovered knowledge.

The notion of philosophy is born in the left foreground. The man with the laurel garland is a portrait of Tommaso Inghirami, the pope's librarian. As his view was that everything that came later was already contained in the writings of Orpheus, he is considered a Bacchantic disciple of Orpheus, and the garland alludes to this. To the right of him is Pythagoras writing down his arithmetical and musical proportions, while in front of Pythagoras is a board with his theory of harmony. Near the centre of the picture, pen-

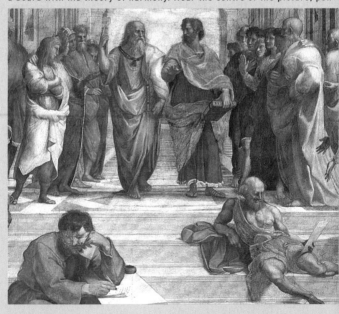

sive, set apart and leaning on a block of marble, is Heraclitus in the figure of Michelangelo, as a form of homage by Raphael to the latter. Behind him (back left) Socrates is teaching a group of male adults. The man in armour among them has occasionally been identified with Alexander the Great. In the middle, standing side by side and dividing the picture into two parts but jointly framed by the vaults, are Plato and Aristotle, the founders of their respective schools. Plato holds the book *Timaeus* with the laws of cosmic harmony he formulated. Aristotle holds his book of *Ethics*, outlining the laws of moral forms of behaviour. They each have six pupils following the debate.

Isolated from the whole discussion is an elderly man draped across the steps. He appears so absorbed in his reading that he notices nothing of the goings on around him. He is thought to be Diogenes. The reason he is given prominence by Raphael may be the intellectual closeness and a similarly unusual way of life of a Roman contemporary called Fabius Calvus, who was Raphael's humanist mentor and lived with him for a time. He translated Hippocrates and Vitruvius's books on architecture for him.

At the foot of the steps on the right is a group clustered around Archimedes, who is wielding a pair of compasses to construct a geometric figure of harmonious proportions. Completing the ranks of philosophers in the fresco are the astronomer Zoroaster with the globe of the heavens and Ptolemy, creator of the geocentric philosophy, holding a globe of the earth. They are looking at the two men on the right edge of the picture, the one in the foreground presumably being Sodoma, who two years earlier had painted the ceiling of the room. Besides him stands his successor Raphael, who ranks himself on the side of the empirical sciences.

A Supreme Master cut down in his Prime

Pope Leo X uses the Stanze for self-representation _ Tapestries for the Sistine Chapel _ The richest man in Rome becomes a great patron _ Raphael's relationships _ A new challenge as architect of St Peter's _ Antiquity becomes the centre of interest _ Posterity mourns a 'divine' artist

Pope Leo X uses the Stanze for self-representation _ The second period of Raphael's supreme mastery came during the reign of Pope Leo X. Unlike his predecessor, Leo was indecisive and frequently changed his mind. More and more, Agostino Chigi, Rome's richest and most successful citizen, became Raphael's principal patron. Growing prosperity meant that from 1513, Raphael was able to move into a palazzo of his own in the Borgo Nuovo. The ground floor was used to print and sell Marcantonio's engravings. Raphael lived on the first floor with his staff and Donna Margherita. He was in contact with Albrecht Dürer, who sent him drawings and a self-portrait. In return, Raphael sent to Nuremberg his *Nude Study of Two Standing Men for the Battle of Ostia* (see p. 48), of 1515. The date and note are by Dürer.

The new pope, whom Raphael already knew from Urbino, exploited every opportunity to have himself painted in the Stanze in various historical roles. However, in *Fire in the Borgo* of 1514 (see p. 48), Raphael moves him so far into the background that he can scarcely be made out any more. The principal figures in the fresco are the simple people fleeing their house on the left because of the fire and the water carrier on the right.

Tapestries for the Sistine Chapel _ In 1514, Leo ordered tapestries for the Sistine Chapel. Raphael designed the ten tapestries while he was working in the third Stanza. Woven in Brussels, they depict the events in the history of the apostles (see p. 49). Seven of Raphael's cartoons survive.

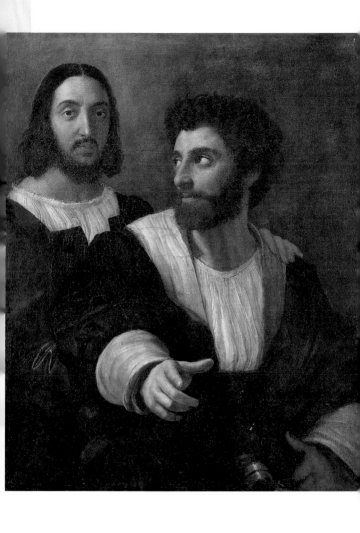

An unknown friend

Double Portrait (Raphael and his Fencing Master), 1520, oil on canvas, 99 × 83 cm,
Musée du Louvre, Paris

Nude Study of Two Standing Men for the Battle of Ostia, 1515, red chalk, metallic slate pencil, 41 × 28.1 cm, Graphische Sammlung Albertina, Vienna

The Miraculous Draught of Fish of 1514/15 depicts the conversion of the disciples. Jesus had been preaching from the boat to the crowd gathered on the shore of Lake Galilee, which features in the background. Thereafter Jesus goes off with the fishermen and a miraculous catch fills the nets to breaking point. In the picture, Jesus speaks calmly and authoritatively to Peter, converting him to a fisher of men. Peter is so terrified by the miracle that he is in a state of exaltation

Roman tragedy

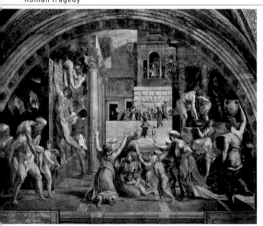

Fire in the Borgo, 1514, fresco, base length *c.* 770 cm, Vatican, Rome

A woven painting

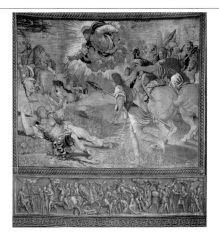

The Conversion of Saul, 1514–19, tapestry, base length without side fringe 557 cm, Pinacoteca Vaticana, Rome

at what is going on, and in deep humility sinks to his knees. Andrew follows suit, his arms outstretched, also knowing the Lord. In the other boat John and James haul in the net. Jesus has just found his first four disciples.

The richest man in Rome becomes a great patron _ The inflow of commissions gradually became so overwhelming that Raphael was no longer able to cope. Even high-ranking clients had to wait for years

Lateral thinking

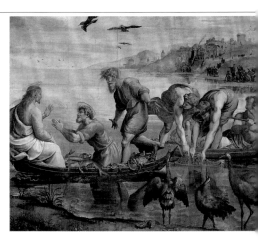

The Miraculous Draught of Fish, 1514/15, chalk, tempera on several sheets paper glued together and fixed on canvas, 319 × 399 cm, Victoria & Albert Museum, London

The Triumph of Galatea, *c.* 1514, fresco, 295 × 225 cm, Villa Farnesina, Rome

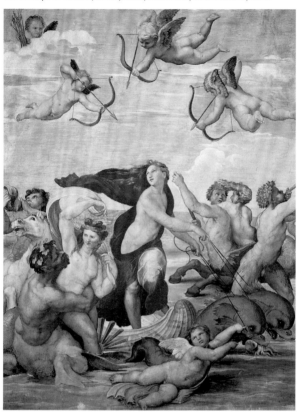

for their works. Raphael left Rome only once again, following the pope to Florence for a commission to design the façade of San Lorenzo. In the event the job was awarded to Michelangelo, who failed to carry it out.

The banker Agostino Chigi was not only influential but also very shrewd. He appreciated Raphael's exceptional quality and induced him to take on more and more commissions for him. After decorating the mortuary chapel in S. Maria della Pace with frescoes, Raphael moved on to design the Chigi Chapel in S. Maria del Popolo. Between 1515 and 1520, the architecture, interior and even the sculptures were all

designed by him. A high point in his work for Chigi were the frescoes at the Villa Farnesina. Now named after its later owners, in Raphael's day this was Chigi's palace on the bank of the Tiber. The construction and interior work were entrusted to the celebrities of the day – Peruzzi and Sebastiano del Piombo, Sodoma and Raphael, the latter doing not only designs for the ceiling paintings *c.* 1514 but also the *Triumph of Galatea* in the Garden Room. In the latter depiction of mythological subject matter, Raphael shows the relationship between Chigi and his beloved Francesca.

The mythological story tells of the Cyclops Polyphemus, who fell in love with the nymph Galatea. He lies on the shore in a separate picture beside the *Galatea*, in which she looks back as she disappears seawards on a conch drawn by dolphins. She is surrounded by sea-centaurs with abducted women – just as Agostino once carried off Francesca. In his work at the Vatican, Raphael had painted Christian subject matter. At the Farnesina, the programme was about the client's personal interests couched in the language of Antiquity.

A chronicler of Renaissance culture

Portrait of Baldassare Castiglione, 1514/15, oil on canvas, 82 × 66 cm, Musée du Louvre, Paris

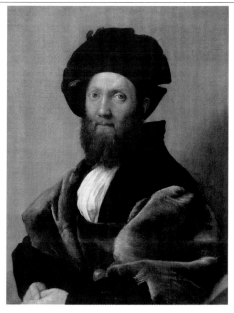

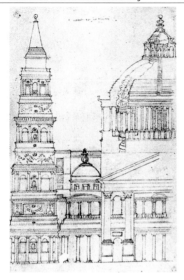

Antonio de Chiarellis, known as **Menicantonio**, Raphael's design for the façade of St. Peter's, pen, brown wash, Pierpont Morgan Library, New York

In his only surviving letter to Count Baldassare Castiglione (dated 1514/15), Raphael writes in connection with *Galatea*: "… to paint one lovely woman I needed to see many and to have your support in choosing the best." This is an indication of his close intellectual relationship with Castiglione, whose portrait he painted that year (see p. 51) – a closeness that is reflected in the eyes of the sitter. Along with Pietro Bembo, who wrote the inscription on Raphael's tomb, and Cardinal Bibbiena, Castiglione belonged to a group of humanists at the court of Urbino. His descriptions of the court have become familiar from his manual for courtiers *Il Cortigiano (The Courtyer)*. Not auctioned off by Rembrandt despite being offered a considerable sum, and later copied by Rubens, the portrait became the epitome of the classic Renaissance portrait.

Raphael's relationships _ More legends than facts are known about Raphael's relationship with women. One fact, however, is that he never married. He wrote sonnets to a high-ranking Roman lady and left a legacy to Donna Margherita, instructing his servants to continue looking after her. She appears in several of his pictures and is possibly even the model for the Sistine Madonna. Raphael arranged with his

friend Cardinal Bibbiena an engagement with the latter's niece Maria, but she died before Raphael at the age of sixteen.

A new challenge as architect of St Peter's _ On 11 March 1514, Bramante died and, on 1 August, Raphael was appointed his successor as the architect of St Peter's. It was Bramante's own wish, expressed on his deathbed. Though Raphael had no formal training as an architect, he nonetheless designed about fifteen churches and private buildings. Bramante planned his own palace in the Borgo – from Raphael's designs. Raphael prepared not only ground plans but also sections and elevations – a systematic form of design that was still new then. Apart

A versatile artist

The Loggias, 1516–19, Vatican, Rome

Scenes from the Life of David, 1516–19, fresco in the eleventh bay of the loggias, c. 400 × 400 cm, Vatican, Rome

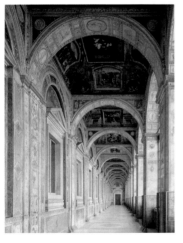
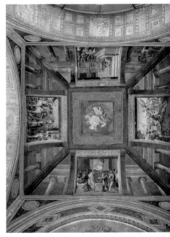

from changing the ground plan of St Peter's, Raphael also endeavoured to introduce classical features. In the event, only a small proportion of these were actually built, but the three-storey loggias were based on his design. The thirteen bays are painted with scenes from the Old Testament, except the last bay, which has incidents from the life of Jesus.

Antiquity becomes the centre of interest _ On 27 August 1515, the Pope appointed Raphael curator of Roman antiquities. Three years

View of the Forum Romanum,
1512, silver point, white highlights/
grey-brown ground on paper,
21 × 14.1 cm, Royal Library,
Windsor Castle

earlier, Raphael had made a drawing of the Forum Romanum in which
the stumps of overturned columns of an ancient building are visible in
the foreground. The former focal point of Rome and other ancient
works of art were buried or overgrown with weeds and undergrowth.
Interest in classical Antiquity was growing only slowly – the Middle
Ages had dismissed its relics as pagan survivals. Raphael's con-
tribution to changing attitudes and helping to save Ancient Rome was
considerable. As Celio Calcagnini reported in 1519: "He shows us the
city itself largely in its ancient guise, grandeur and symmetry are
being restored ... so that almost everyone looks on him as a god sent
from heaven to restore the Eternal City to its ancient majesty."

For Cardinal Bibbiena's rooms in the Vatican, Raphael drew up
a programme of decorations that would have been impossible prior
to his rediscovery of Antiquity before 1516. In this, classical subject
matter and decorative features are introduced into a work of modern
times. An attempt was even made to imitate the techniques of encaus-
tic painting. The decorations of the Loggetta go back to the Domus

54

Aurea, and these became a reference work of grotesque ornamentation throughout Italy.

In his last years in Rome, Raphael's long-standing connections with the court of Urbino brought him further commissions. Duke Lorenzo de' Medici of Urbino (see p. 56) was ambassador to the French court, and for François I he ordered a *Holy Family with St Elizabeth, St John and Two Angels (François I Madonna)* (see p. 56) and a *St Michael* (see p. 57). The following year, Celio Calcagnini reported admiringly of Raphael's work: "He excels greatly in the virtues and is effortlessly the prince of painters both in theory and in practice. He is an architect of such zeal that he designs and completes what perhaps even the most capable minds might despair of."

Posterity mourns a 'divine' artist _ On 6 April 1520, Raphael died after a two-week illness during which the Pope visited him virtually every day. He left behind unfinished works both great and small for his stricken workshop to complete. The extent of the loss can be judged from the tomb inscription in the Pantheon by Cardinal Pietro Bembo:

Imperial decorations for a cardinal

Loggetta of Cardinal Bibbiena, 1516, frescoes, Vatican, Rome
Stufetta of Cardinal Bibbiena, 1516, frescoes, Vatican, Rome

This is Raphael's tomb. While he lived, Nature feared
His victory; when he died, that it would die with him.

Though contemporaries of Raphael left written records of their own lives, some of them detailed, this seems to have been for Raphael an unimportant use of his time. Little is known of his personal life – indeed, it almost seems as if he did not have one. There is nothing to mar his reputation. This is reflected even in descriptions by those who

Portrait of Lorenzo de' Medici, 1518, oil on canvas, 99 × 81 cm, Ira Spanierman Collection, New York

Holy Family with St Elizabeth, St John and Two Angels (François I Madonna or Holy Family), 1517/18, oil on panel, mounted on canvas, 207 × 140 cm, signed RAPHA.EL VRBINAS PINGEBAT M.D.X.VIII, Musée du Louvre, Paris

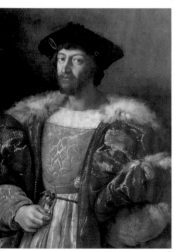
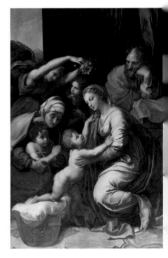

later wrote of him. Vasari refers to Raphael as a 'mortal god'. Centuries later, Ingres talks of the "spiritual being come down from heaven." The Romantic poet Achim von Arnim described Raphael as someone who "attached himself to Earth without belonging to it; his kiss was like an angel's farewell to Earth leaving it in the morning dew, ascending to the eternal firmament." But perhaps the most moving tribute of all was paid to him by Hermann Grimm: "Raphael was something of a spirit that wanders over the earth leaving no mortal footprints behind."

.. for the French king

St Michael, 1518, oil on panel, mounted on canvas, 268 × 160 cm, signed RAPHAEL
VRBINAS PINGEBAT MD.XVIII, Musée du Louvre, Paris

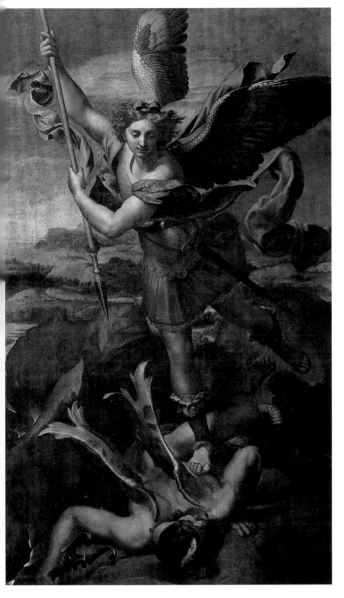

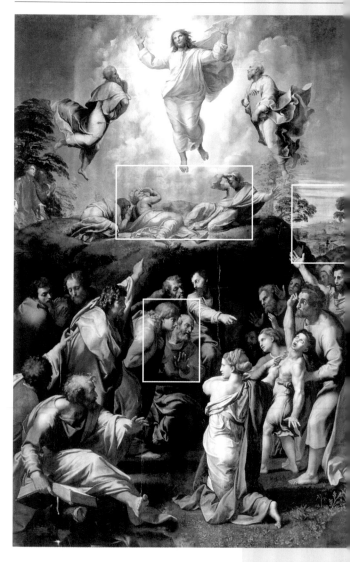

The Transfiguration, 1519–20, oil on panel, 405 × 278 cm,
Pinacoteca Vaticana, Rome

The Transfiguration

Raphael's last painting _ A legacy for Christianity and artistic posterity

Cardinal Giulio de' Medici, later Pope Clement VI, ordered *The Transfiguration* in 1517, wanting it for his episcopal seat in Narbonne Cathedral in Languedoc. Raphael began the picture in 1519, but left it unfinished at his death the following year. However, as recent research has shown, these involved only minor parts of the picture. A new cooler palette was also established that created the impression of porcelain in its fine gradations, indicating the influence of Venetian coloration. *The Transfiguration* was Raphael's last picture. After Giulio de' Medici decided to leave it in Rome, it was exhibited during Raphael's interment in the Pantheon. Vasari commented: "The contrast between the vivid picture and the dead body filled everyone who saw it with bitter sorrow." Three years later it was moved to the church of S Pietro in Montorio as a high altar, where it remained almost 300 years.

In the Gospels, the Transfiguration of Christ on Mount Tabor is reported as a supernatural event. Christ went up the mountain with Peter, John and James to pray. Moses and Elijah appeared, initially unnoticed by the disciples. When they finally noticed them, a cloud appeared, out of which the voice of God spoke, terrifying the disciples. This is the event depicted in the upper half of the picture. Blinded by the light of the divine cloud, the disciples have fallen to the ground. Christ appears

above them transfigured, with the two Old Testament prophets beside him.

Studies of heads and hands for two apostles in the Transfiguration, 1519–20, chalk and white highlights, outlines embroidered, 44.9×36.4 cm, Ashmolean Museum, Oxford

The lower half of the picture depicts the healing of a possessed boy, an event that follows the Transfiguration in the Bible. Whereas the figures in the upper half are composed harmoniously within the shape of a circle, the group below is divided into two: the subgroup on the left pushing forwards and making space for themselves, and the shocked, anxious figures on the right around the possessed boy in retreat. Every figure is given a precise individual cast in terms of emotion, gesture and expression, as the associated sketches make clear. In the upper half, everything revolves around the centre while, below the centre, there is an almost unbridgeable gap between the two groups.

The zone that takes the eye on to a far distant landscape is kept very small. In contrast to the soft evening light there, the cool light in the foreground gives the scene a supernatural, unreal look. The marked chiaroscuro, which in Leonardo produces a muted local colour, links Raphael with the vivid col-

oration of the painting tradition he came from. His interest in the theatre at the time may have inspired the way he handled the lighting.

As preparatory sketches proves, Raphael's initial intention was to paint only the actual theme of the transfiguration, but expanded the narrative making a key statement of faith. He does not depict not the moment when Jesus heals the boy but the prior failure of the disciples in their attempts. They have come together believing in a cure and thus believing in Christ; the Risen Christ is, therefore, present as a healing force. Two temporally distinct moments come together in this work of Raphael's most mature stage of development to form a unity in Christian faith.

The Transiguration was particularly influential on the Mannerists who came after the Renaissance. The work contains qualities which to some extent recur only several decades later. The landscape looks forward to the later sixteenth century, for example with the Carraccis. Even further in the future is this special treatment of light, showing the figures sharp, and invested with theatrical character. It would not be until Caravaggio and the seventeenth century that paintings like this would be produced again.

Where can Raphael's works be seen?

Edinburgh●

Oxford●
Windsor● ●London

● Caen
●● Chantilly
Paris

New York
Washington D.C. ●

● Los Angeles

Montpellier ●

North America

● Madrid

St Petersburg

● Berlin

● Dresden

● Munich ● Vienna

● Milan

● Florence

● Rome

A selection of museums housing some
of Raphael's most famous works:

(**G**): Graphic works: etchings, drawings
(**P**): Oil Paintings, frescoes

Berlin
Staatliche Museen zu Berlin –
Preußischer Kulturbesitz
Gemäldegalerie Kulturforum
Matthäikirchplatz 4
www.smb.spk-berlin.de (**P**)

Caen
Musée des Beaux Arts
Le Château
www.ville-caen.fr/mba/ (**P**)

Chantilly
Musée Condé
Chateau de Chantilly
www.chateaudechantilly.com (**P**)

Dresden
Staatliche Kunstsammlungen
Dresden
Gemäldegalerie Alte Meister
Semperbau am Zwinger
www.skd-dresden.de (**P**)

Edinburgh
National Gallery of Scotland
The Mound
www.natgalscot.ac.uk (**P**)

Florence
Galleria degli Uffizi
Via della Ninna 5
www.uffizi.firenze.it (**G**, **P**)

Palazzo Pitti
Piazza Pitti 5
www.palazzopitti.it (**P**)

London
National Gallery
Trafalgar Square
www.nationalgallery.org.uk (**P**)

Victoria & Albert Museum
Cromwell Road
www.vam.ac.uk (**P**)

Los Angeles
The J. Paul Getty Museum
1200 Getty Center Drive,
www.getty.edu (**P**, **G**)

Madrid
Museo del Prado
Paseo del Prado
www.museoprado.mcu.es (**P**)

Milan
Pinacoteca di Brera
Via Brera 28
www.brera.beniculturali.it (**P**)

Montpellier
Musée Fabre
39 Boulevard Bonne Nouvelle
www.montpellier-agglo.com (**G**)

Munich
Bayerische Staatsgemälde-
Sammlungen, Alte Pinakothek
Barer Straße 29
www.pinakothek.de (**P**)

New York
Metropolitan Museum of Art
1000 5th Avenue at 82nd Street
www.metmuseum.org (**G**)

The Pierpont Morgan Library
29 East 36th Street
www.morganlibrary.org (**G**)

Oxford
Ashmolean Museum
Beaumont Street
www.ashmol.ox.ac.uk (**G**)

Paris
Musée du Louvre
34–36, Quai du Louvre
www.louvre.fr (**G**, **P**)

Rome
Galleria Borghese
Villa Borghese
Piazza Scipione Borghese 5
www.galleriaborghese.it (**P**)

Palazzo Apostolico and Pinacoteca
Vaticana
Viale Vaticano
www.vatican.va (**P**)

Villa Farnesina
Via della Lungara 230
www.abcroma.com (**P**)

St Petersburg
State Hermitage Museum
34 Dvortsovaya Naberezhnaya
www.hermitagemuseum.org (**P**)

Vienna
Albertina
Graphische Sammlung
Albertinaplatz 1
www.albertina.at (**P**, **G**)

Liechtenstein Museum
The Princely Collections
Fürstengasse 1
www.liechtensteinmuseum.at (**P**, **G**)

Kunsthistorisches Museum
Maria Theresien Platz
www.khm.at (**P**)

Wahington D.C.
National Gallery of Art
Constitution Avenue
Between 3rd and 9th Streets NW
www.nga.gov (**P**, **G**)

Windsor
Windsor Castle
Royal Library
www.royal.gov.uk (**G**)

More about Raphael: a selection of books on the artist and his work

There is a large amount of literature about Raphael, focusing on different aspects of his life and work.

One of the most informative **biographical works** on Raphael is G. Vasari, Vasari's Lives of the Artists; Biographies of the Most Eminent Architects, Painters, and Sculptors of Italy, New York 1998. The book was first published in 1550; the edition mentioned here, which includes an introduction and notes by Julia Conaway Bondanella and Peter Bondanella, has also been translated by the authors.

Examples of other books treating Raphael's life and the **artist's impact on the history of art** and on the work of his contemporaries are: J.A. Crowe and G.B. Cavalcaselle, Raphael: His Life and Works, 2 vols., London 1882–83; V. Golzio, Raffaello nei documenti, nelle testimonianze dei contemporanei e nella letteratura del suo secolo, Vatican 1936; M. Salmi, ed., Raffaello, l'opera: Le fonti, la fortuna, 2 vols., Novara 1968 and Passavant Johann David, Raphael of Urbino and his father Giovanni Santi, New York 1978.

Established **standard works** concentrating specifically on Raphael that can be recommended include: G.P. Bellori, descrizione delle immagini dipinte da Raffaele d'Urbino, Rome 1695 (English translation 1968); J. Richardson and J. Richardson, An Account of the Statues, Bas-reliefs, Drawings and Pictures in Italy, France, etc. with commentaries, London 1722 and J. C. Robinson, A Critical Account of the Drawings by Michel Angelo and Raffaello in the University Galleries, Oxford, Oxford 1870.

More recent publications covering several aspects of Raphael's life and works are: L. Dussler, Raphael, London 1971; P. Johannides, The Drawings of Raphael with a Complete Catalogue, Oxford 1983; R. Jones and N. Penny, Raphael, New Haven and London 1983; K. Oberhuber, Raphael: The Paintings, Munich et al. 1999; Pierluigi De Vecchi, Raphael,

New York 2002. Oberhuber's book is beautifully illustrated with high-quality reproductions, including many details. It is a thoroughly scholarly reconstruction of the complex historical, cultural and artistic currents that influenced the artist's achievements.

A variety of books focus on **specific works** by Raphael, ranging from his architectural drawings to the frescoes in the Villa Farnesina: Dussler, Luitpold, Raphael: a critical catalogue of his pictures, wall-paintings and tapestries (trans. by Sebastian Cruft), London, New York, 1971; Fischel, Oskar, Raphael (trans. by Bernard Rackham), London 1948 – a beautiful publication including 302 plates – and Müntz, Eugène, Raphael; his life, works and times (trans. and edited by Walter Armstrong). Of particular interest is Frommel, L., S. Ray and M. Tafuri, eds. Raffaello Architetto, Milan 1984, which explores the work of Raphael in the field of architecture. A fascinating publication is Raphael's cartoons in the collection of Her Majesty the Queen, and the tapestries for the Sistine Chapel, by John Shearman, London 1972.

The **Stanza della Segnatura** was the first of Pope Julius II's rooms in the papal appartments in the Vatican to be decorated with Raphael's frescoes. The publication by James Beck, Raphael: The Stanza Della Segnatura (The Great Fresco Cycles of the Renaissance), New York1993, offers an exhaustive account of Raphael's work which symbolises the humanist quadripartition of culture – theology, philosophy, poetry and justice.

As numerous as the publications on Raphael are the exhibitions of his works and the respective **catalogues**: J.A. Gere and N. Turner, Drawings by Raphael from the Royal Library, the Ashmolean, the British Museum, Chatswoth and other English Collections, London 1983, British Museum; M. Clayton, Raphael and His Circle: Drawings from Windsor Castle, London (Royal Collection) 1999 and H. Chapman, T. Henry and C. Plazzotta (The National Gallery London), Raphael: From Urbino to Rome, London 2004.

Raphael's Self-Portraits

Raphael left few self-portraits. It was apparently a subject that interested him as little as leaving his own written records. In the few portraits that do exist, he features with a grave, alert and interested expression and relaxed facial features. The harmony which even his contemporaries admired applied equally to the elegance of his face, in which perfection, grace and dignity are reflected. In the early pictures, it is only a matter of pure self-portraits. The later ones are no longer autonomous self-portraits – the context has expanded.

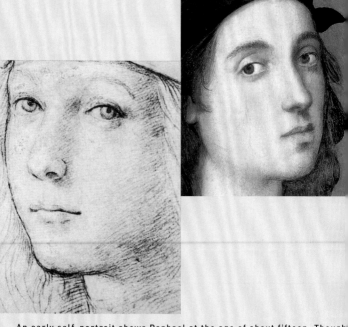

An early self-portrait shows Raphael at the age of about fifteen. Though the chalk drawing is overall rather delicately executed, the interesting features of eyes, mouth and outline are drawn in with more vigour. Raphael's capacity for understanding, physical modelling and lighting is already very marked. The portrait shows a clear interest in his own individuality, which may have been the result of his early familiarity with mature humanism.

s in the early chalk drawing, the self-portrait from Florence, when he
was around twenty-three, leaves out the hands, and therewith all ges-
tures. The entire focus is on the facial features. The frank gaze of the
youthful face conveys a touch of melancholy. The picture, which has
determined the general image of what Raphael looked like, is cropped
on the left, has repeatedly been cleaned and over-painted, and has
thereby lost its original clarity.

Four years later, Raphael put his own portrait into the *School of Athens*.
The portrait looks like a repetition of the previous one, only back to
front. Even the lighting and headgear match the oil painting. Now twen-
ty-seven, Raphael seems hardly any older, and as in the previous por-
traits wears a plain biretta. As purely an observer of the scene, he has
placed himself on the edge as the sole figure looking at the viewer.

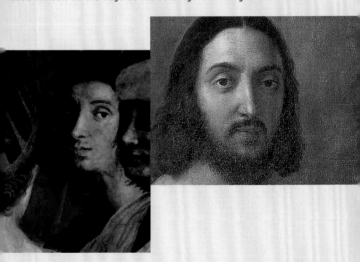

In the double portrait with the fencing master, Raphael is in the back-
ground. He has put his friend in the centre of the picture. His hand
rests languorously on the shoulder of the lively, unknown young man.
Raphael still preserves his soft features, no external features indicat-
ing that he was now thirty-seven. And yet there seems a tiredness
around the eyes – reference is made repeatedly to his ageing prema-
turely. And in the year of his death, a report said that he was suffering
from strain due to excess work.

Achim von Arnim German poet, 1781–1831. Main representative of the later Romantics, who combined a natural conservatism with remarkable fantasy in his works.

Bacchus *Dionysius* in ancient Greece, the god of wine and intoxication. Celebrated in Rome as Bacchus with Bacchanalian festivals. Initially depicted as a bearded, ivy-garlanded old man, from the 5th century he was also shown as a young man. Interest in him revived during the Renaissance.

Cartoon A full-size preliminary drawing on heavy paper done in charcoal, graphite, chalk or ink in preparation for a fresco. The drawing is fixed to the wall and the picture transferred to the wall either by pouncing (perforating) or pressing it through on to damp plaster.

Celio Calcagnini 1479–1541. Latinist, from 1520 professor at the Ferrara Academy, a friend of Erasmus of Rotterdam and familiar with the theories of Copernicus, who studied in Ferrara.

Chiaroscuro (ital. *light-dark* Emphasis on light and shadow effects in the picture. Leonardo explored its possibilities systematically, and from 1500 perceptible light source began to become evident in painting, with associated chiaroscuro effects.

Diptych (Gk. *folded double*) Small wooden panels or more costly materials joined one side, a format already found in antiquity. Inside was a precious carving or else a layer of wax for writing. In the Middle Ages, it took the form of a two part altar, initially depicting the Virgin and Christ, but later included donors and patron saints.

Disputa A visual representation of a discussion about theological doctrines.

Encaustic (Gk. *burnt in*) Painting technique already used in ancient Greece, where wax was used as a binder for colour pigments. Heated to high temperatures, the colour paste was applied with spatulas or more thinly with bristle brushes. The coated wood, gypsum or lime plaster support combines with the paint into a weatherproof, very durable surface. As tempera